Doodle Your Way Thru...Art History

Char Green

4Him

Copyright © 2017 Char Green
ISBN-13: 978-1546316473
ISBN-10: 1546316477

Cover Art by Char Green

4Him

Also by Char Green

Doodle Your Way Thru...Affective Learning

Doodle Your Way Thru...Your Feelings

Doodle Your Way Thru...The Amazing Brain

This book is dedicated to my sweet husband Tom Green and our children Alex, Jake, Katie, and Meredythe and my dad Bob Bullinger (Jackie) and my mother, the late Dorothy Bullinger. A big shout out to Kelley Taylor for introducing me to the concept, Greg Mitchell for talking me through publishing, Starla Wood for being my partner in crime, Maria Vowell for the time spent editing, and my aunt Donna Hale (Jess) for handling all the tedious things that I don't have the attention span to handle. I need to also give thanks to my prayer warriors and above all, thank you God for all of your good gifts!

<div style="text-align:center">4Him</div>

INTRODUCTION

This book was conceived through research, observation, divine inspiration, and other important and quotable means. Educators have finally begun to learn the importance of doodling. You read that correctly! Doodling is important for learning. Doodle Your Way Thru...Art History allows the student to take control of a large portion of the learning.

The following pages have been put together so that you, the educator, will have another means at your disposal to assist with and enhance the learning. You may choose to use this book in a classroom setting, in a homeschool setting, as a companion to a textbook, along with internet search engines, or simply for use by a substitute in your absence. Each of these 8 1/2 x 11 pages is full of ideas, activities, and information to help you to enhance and extend the learning, as well as prep students for assessments. You may choose to purchase a single book and make copies as needed or you may opt to purchase individual books for each student and thereby have an already-bound portfolio of their classroom work. I have included a rubric that I created and that I use in my classroom. Feel free to use as-is or tweak it the way you would like it. There is also a lesson plan page and a page for jotting down quick reflection notes. I've created this book and all the books in this series to be as educator-friendly as possible.

4Him

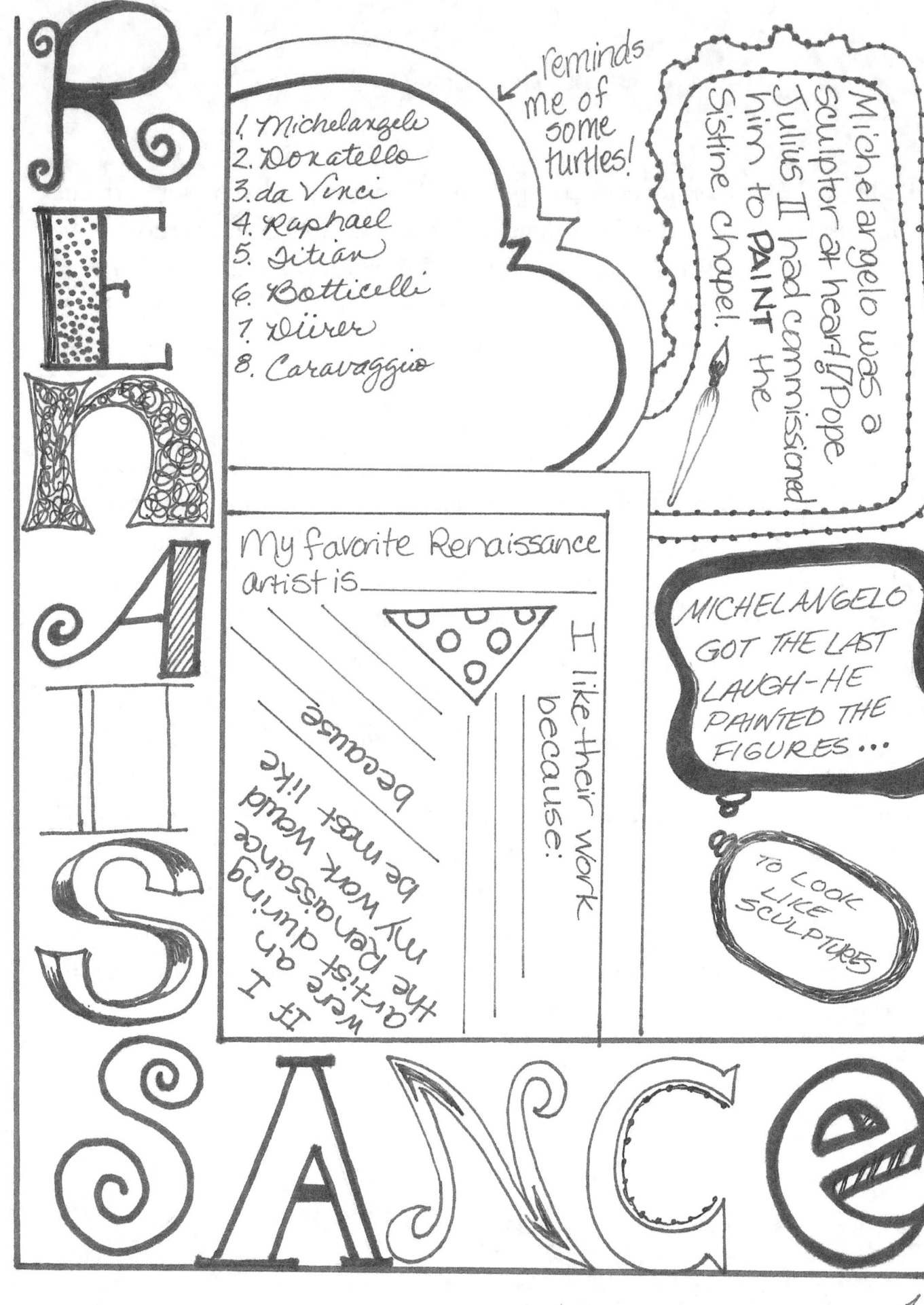

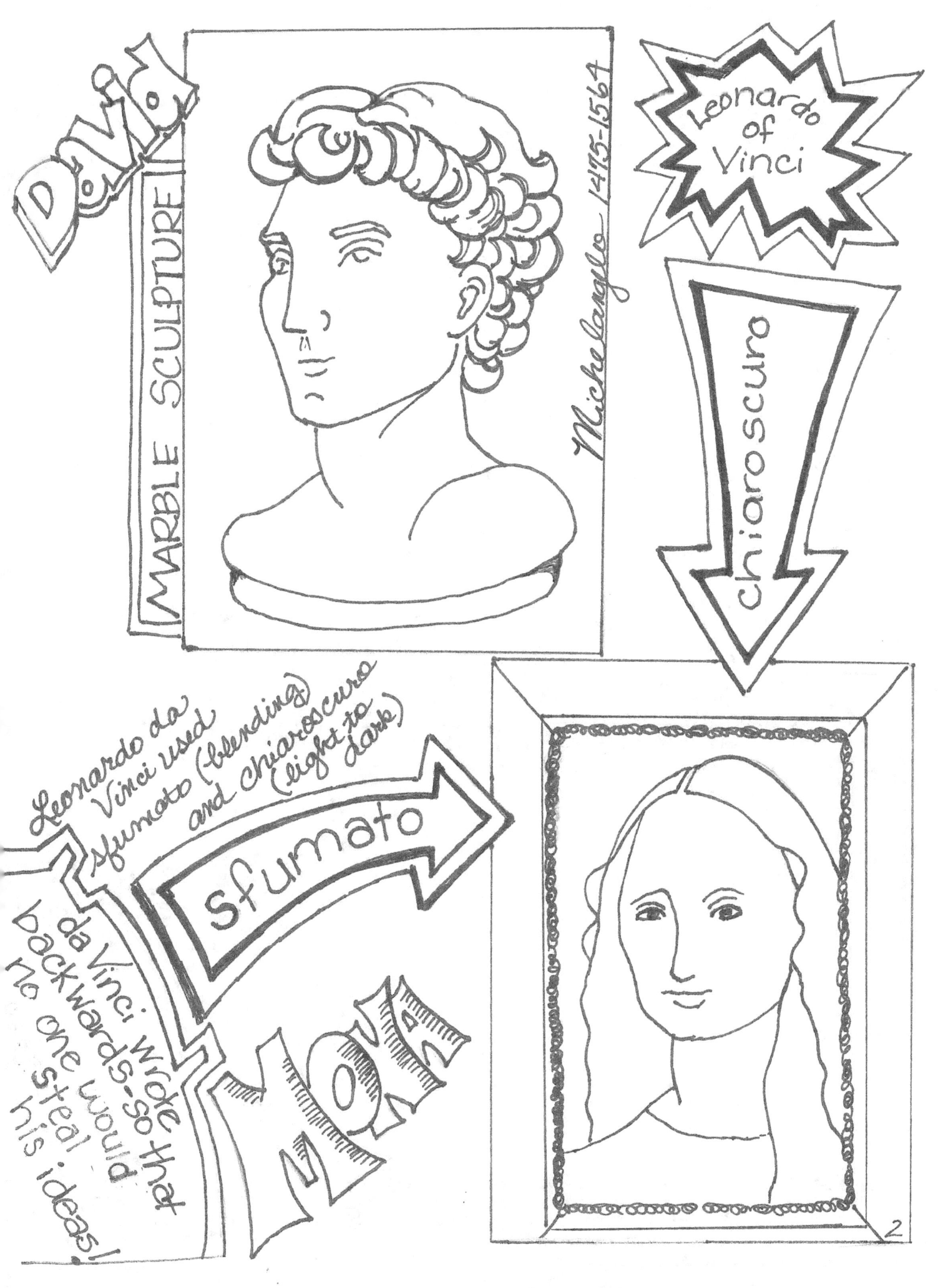

his name is a *prepositional phrase* !!!

Leonardo da Vinci Inventions:
- flying machines
- helicopter
- parachute
- scuba gear
-
-
-

{ add 3 more inventions

Renaissance -
List 7 features
1.
2.
3.
4.
5.
6.
7.

Venus on the Half Shell

and Pope Julius II commissioned him to paint the Sistine Chapel in 1508

→ Michelangelo

Use multi-colored ink pens to recreate a Renaissance piece with a stipple technique

"Without hope, without fear"

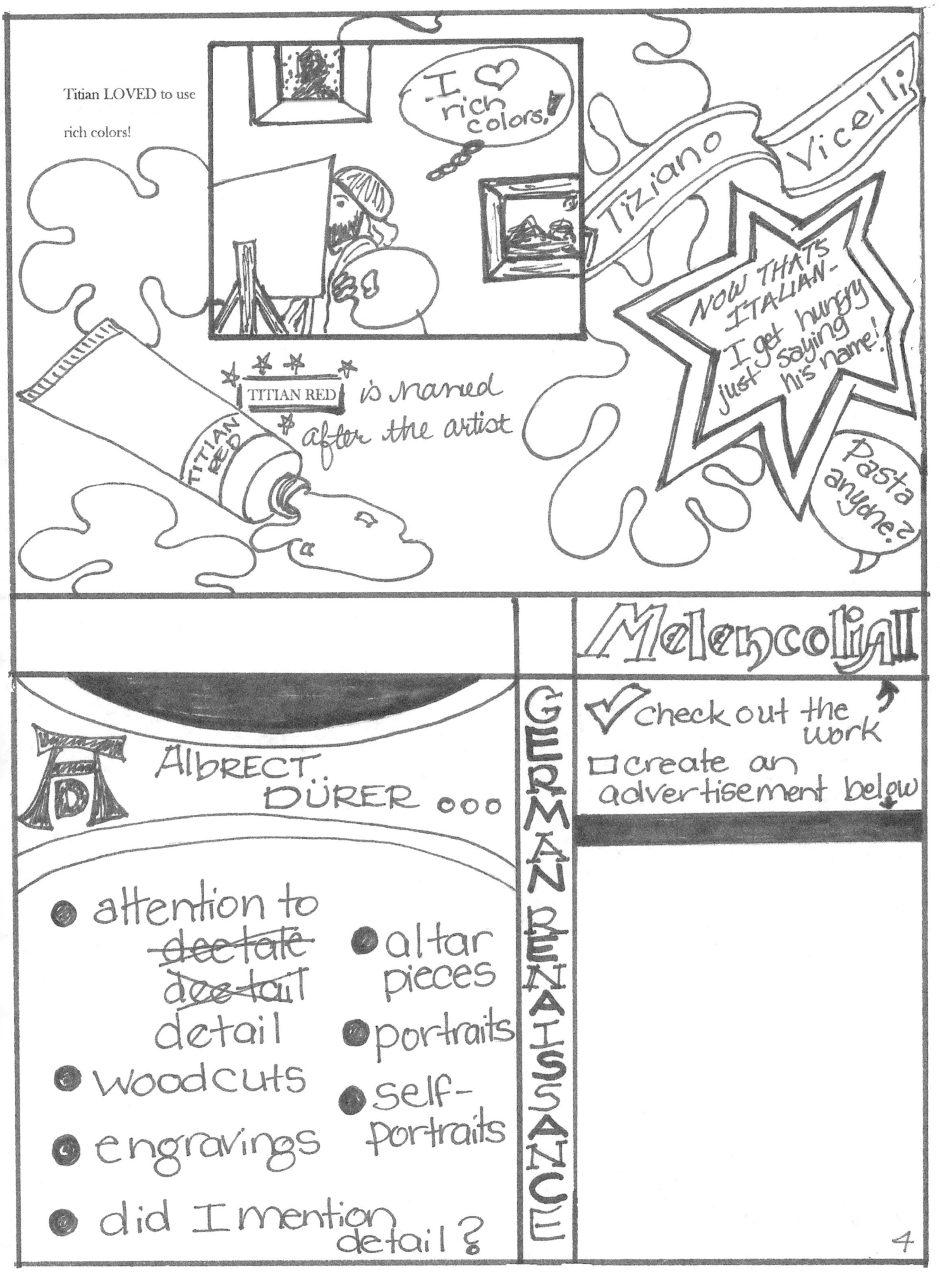

DONATELLO (1386-1466)
Painter & *Sculptor*

- David
- Saint Mark
- Judith and Holofernes
- Feast of Herod

Titian
trained UNDER
Peterzano
trained UNDER
Caravaggio

Caravaggio

1596 MEDUSA

talk about a bad hair day! ☺

Its nothing personal, just thought it would be a fun assignment!

create a self-portrait as Medusa

MICHELANGELO MERISI DA CARAVAGGIO

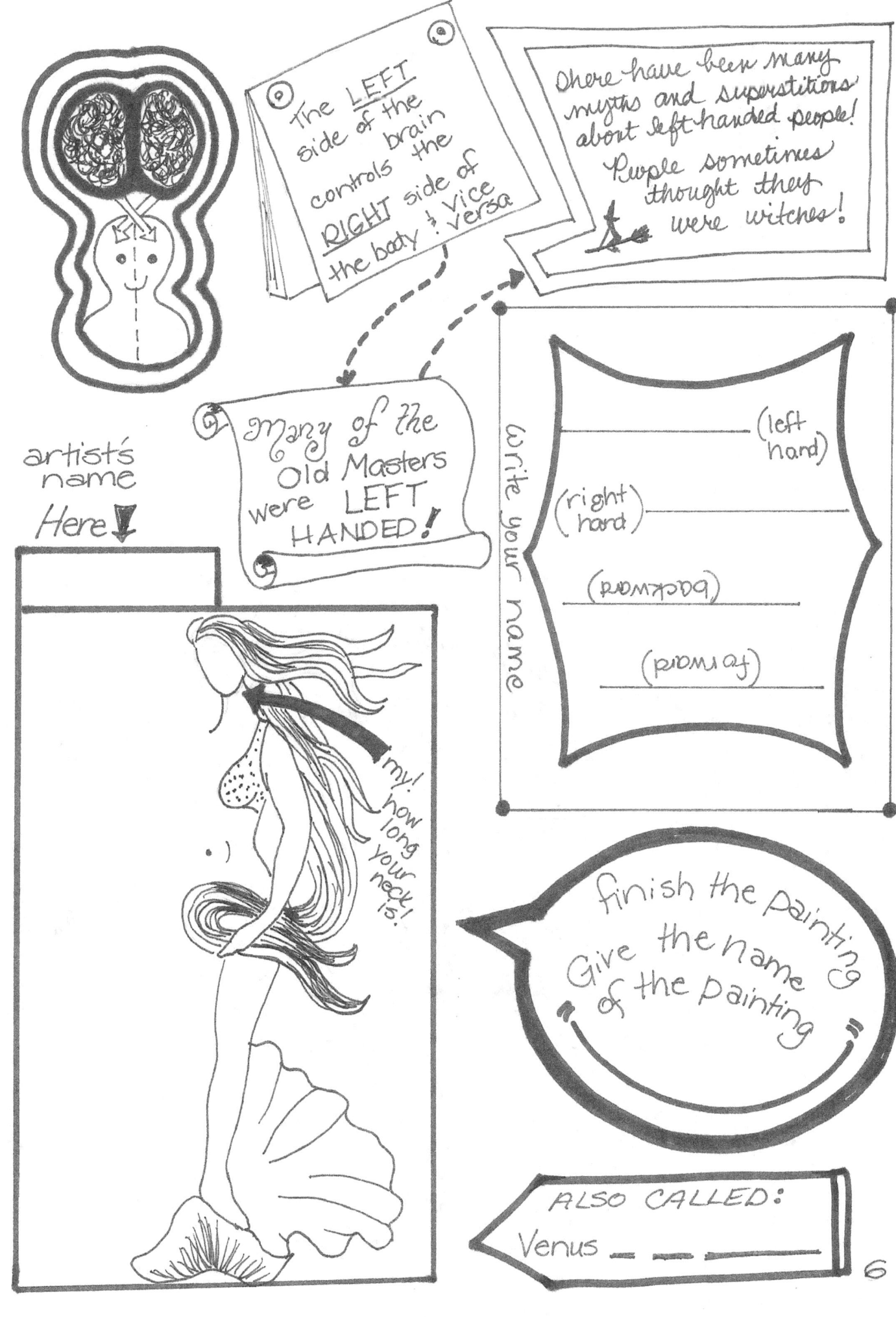

RAPHAEL 1483-1520

Garden of praise

RENAISSANCE means "Rebirth"

* school of athens
* transfiguration
* the sistine madonna
* the marriage of the virgin
* three graces
* saint george & the dragon

Raphael's Madonnas are their own category in Italian Renaissance with over **30** classified pieces

Saint John the Baptist, Madonna of the Meadow, Madonna with the Christ Child and

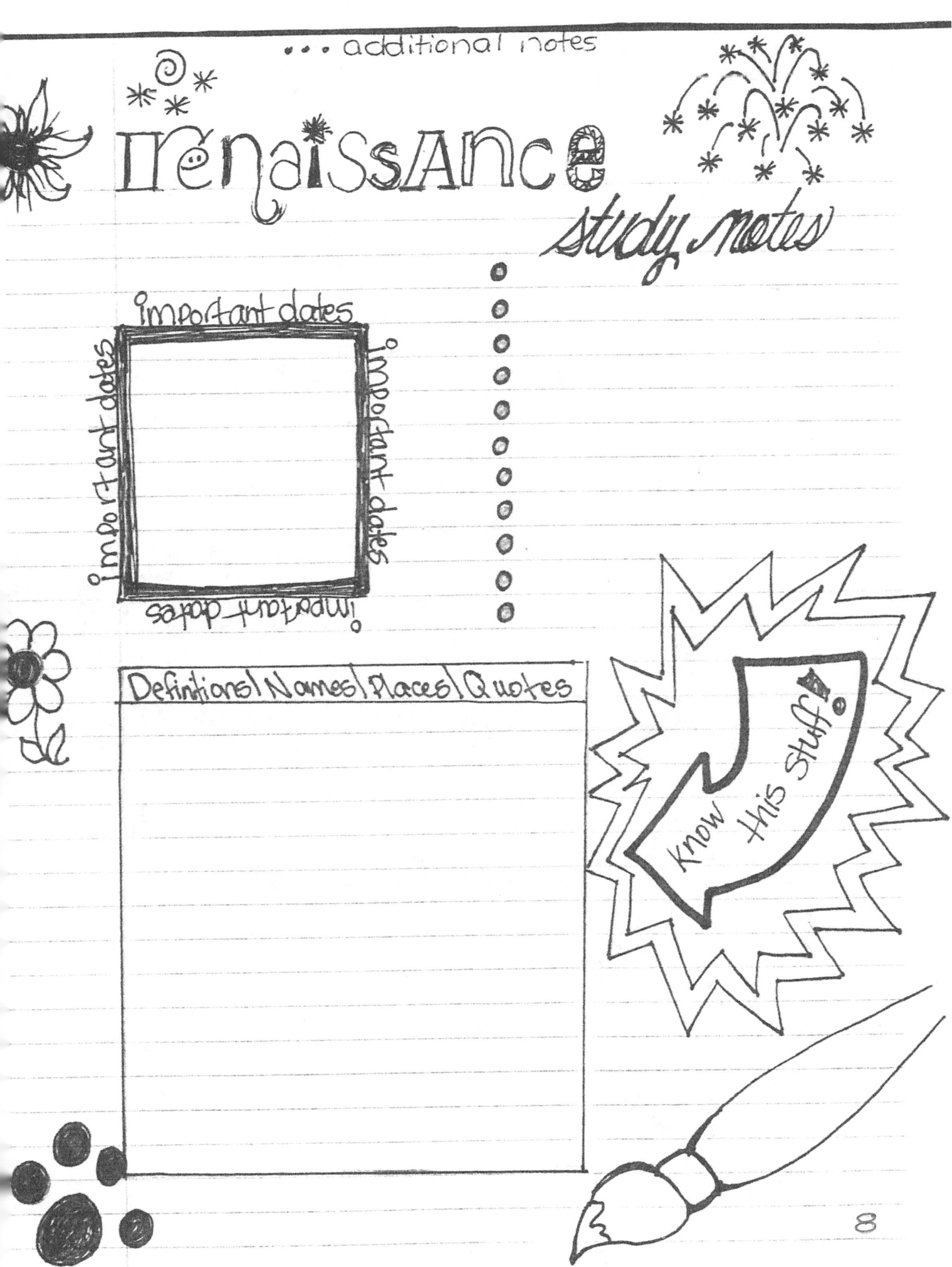

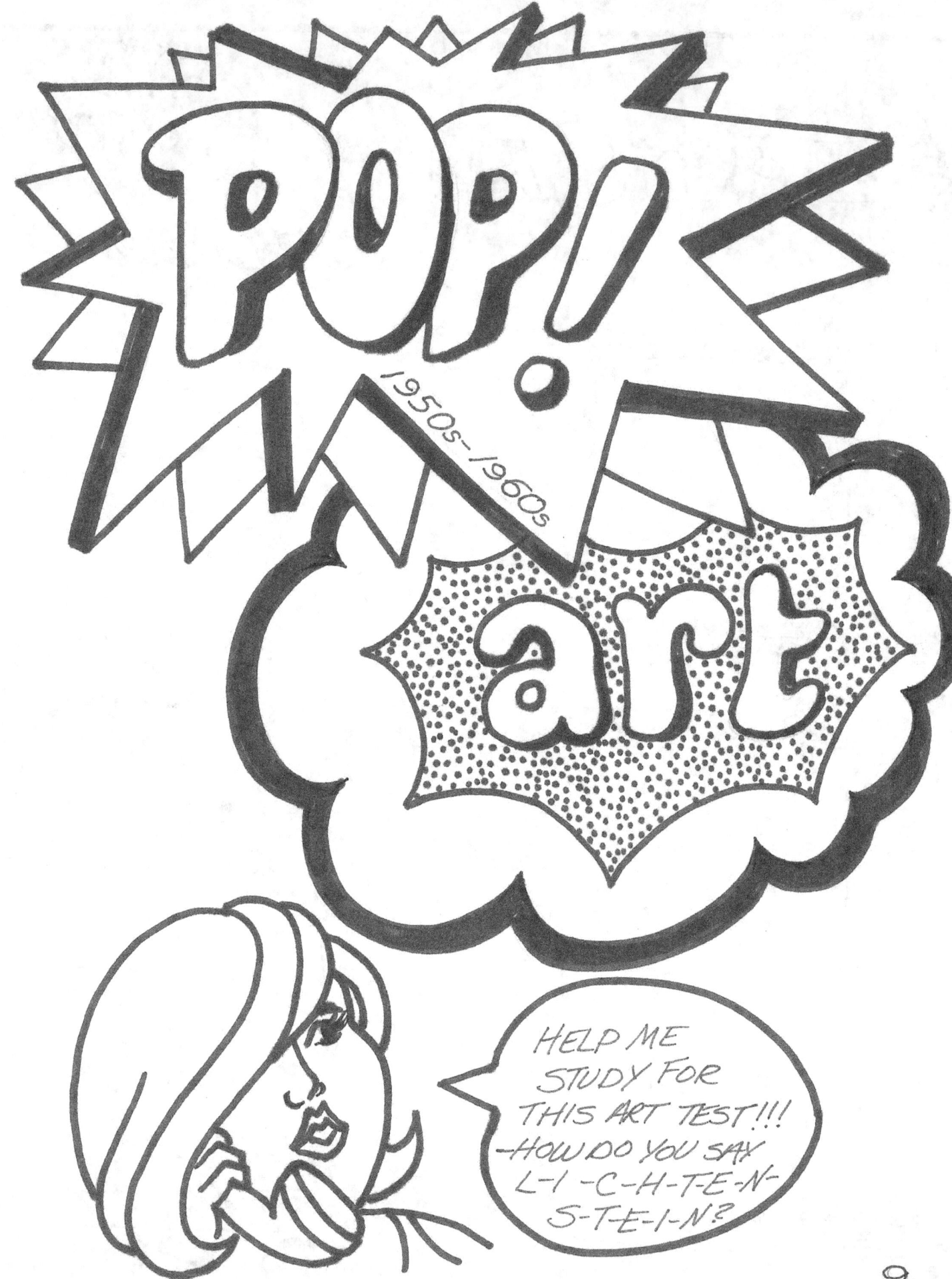

andy WARHOL
"Fifteen minutes of fame" 1928-87

- Commercial Art
- Screenpainting

Jasper Johns

6 7 5
8 6 9 8
3 8 0 9
 3 0

10

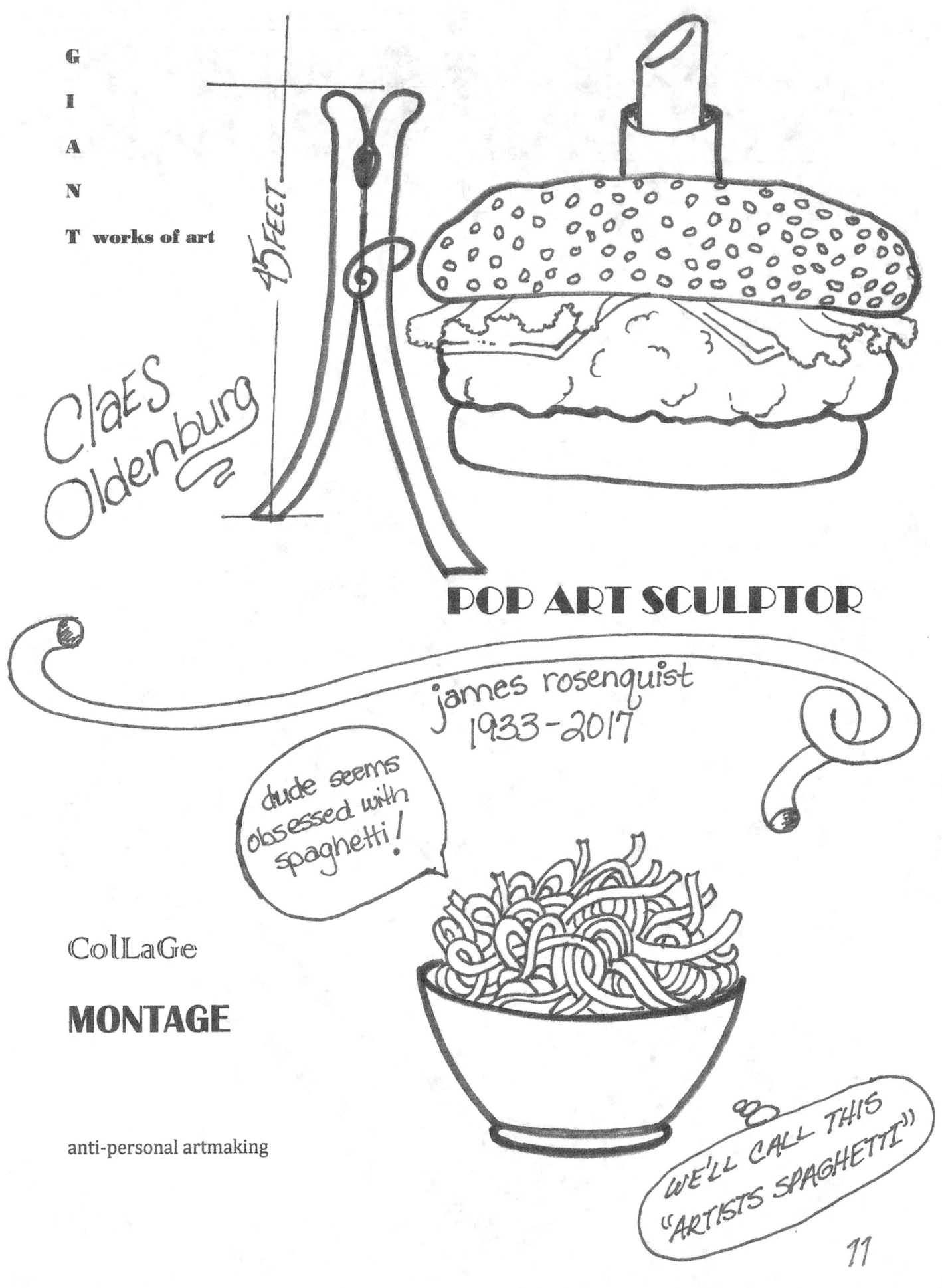

PoP art

...additional notes ♪

POP ARTISTS

some themes of pop art

12

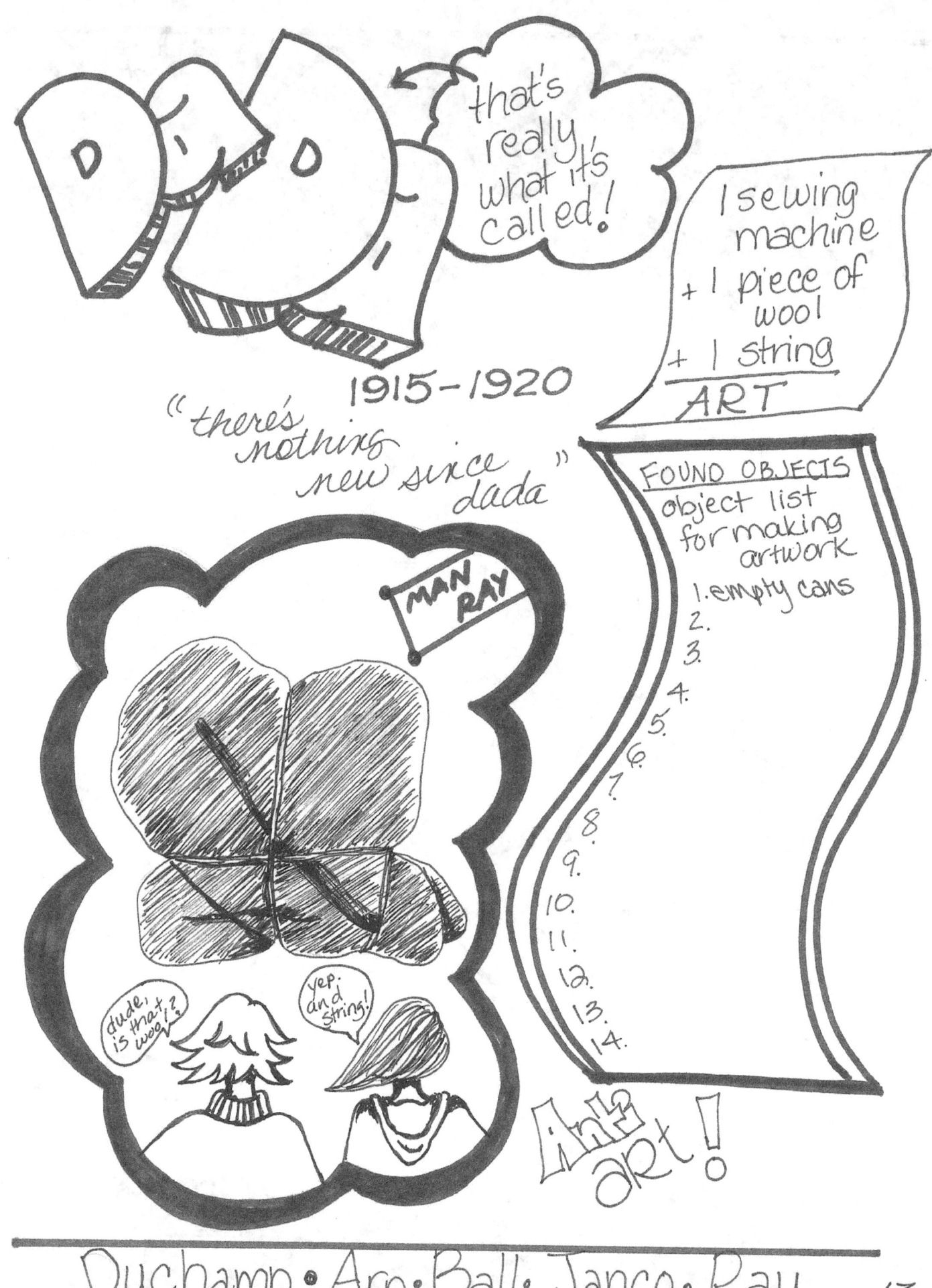

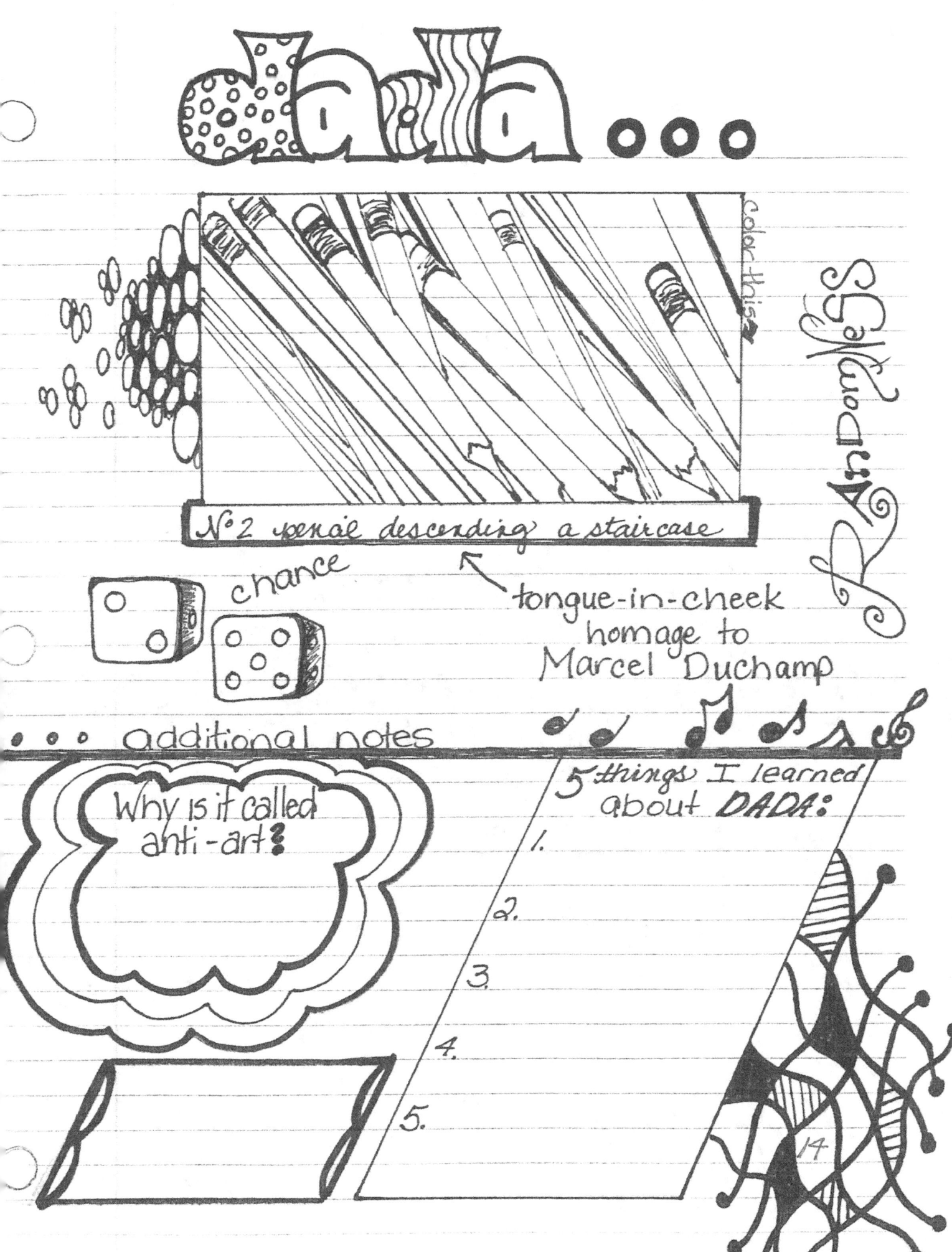

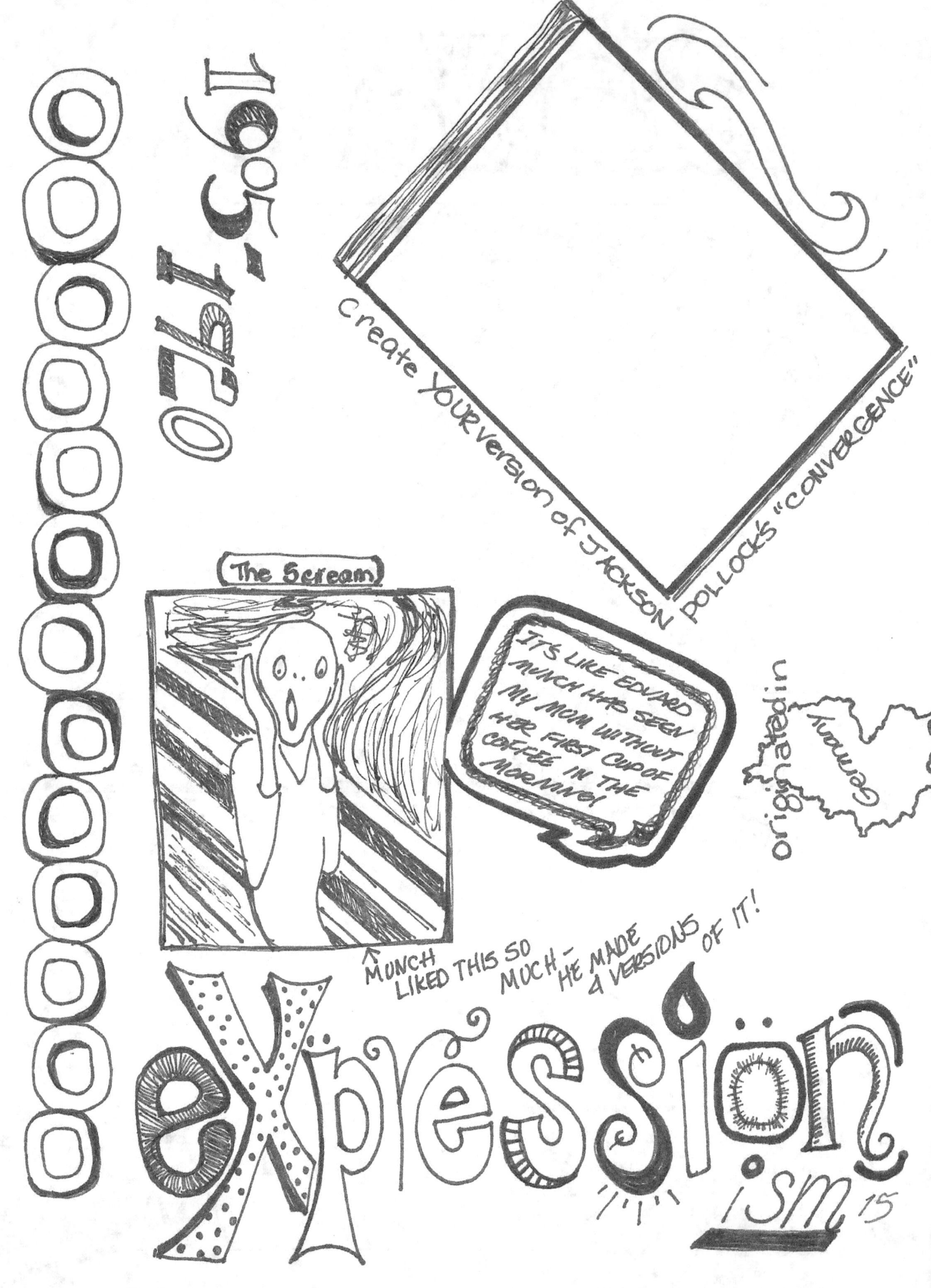

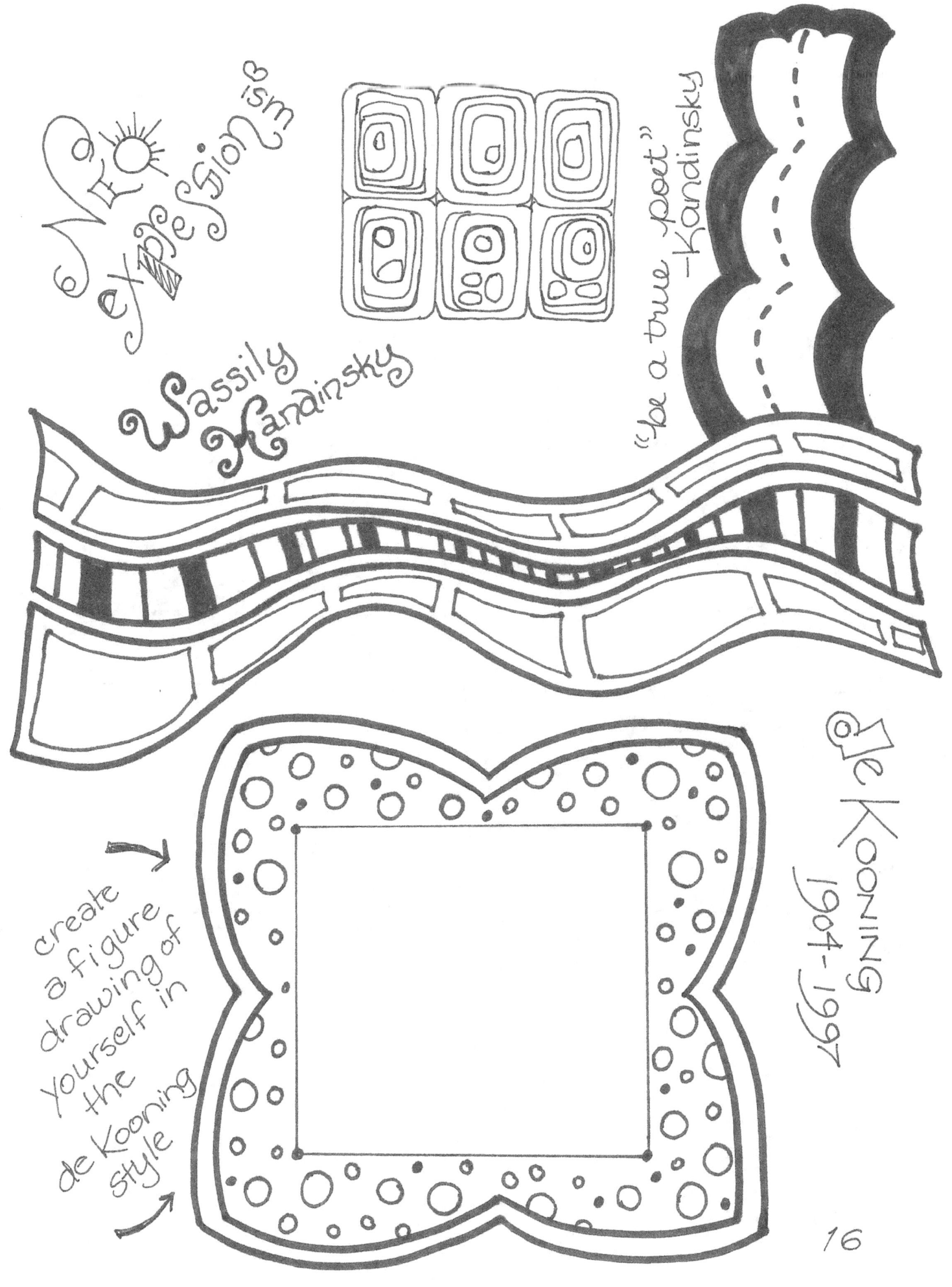

"I try to intensify my sensitivity for the organic rhythm of all things"
— Franz Marc

The Yellow Cow

COLOR SYMBOLISM

Yellow = safe

Check out the painting, it's really yellow!

FranZ MarC

MARK RoThKo

American Abstract expressionist

(he wanted to bring people to tears)

modernist movement - subjective, personal, spontaneous

11

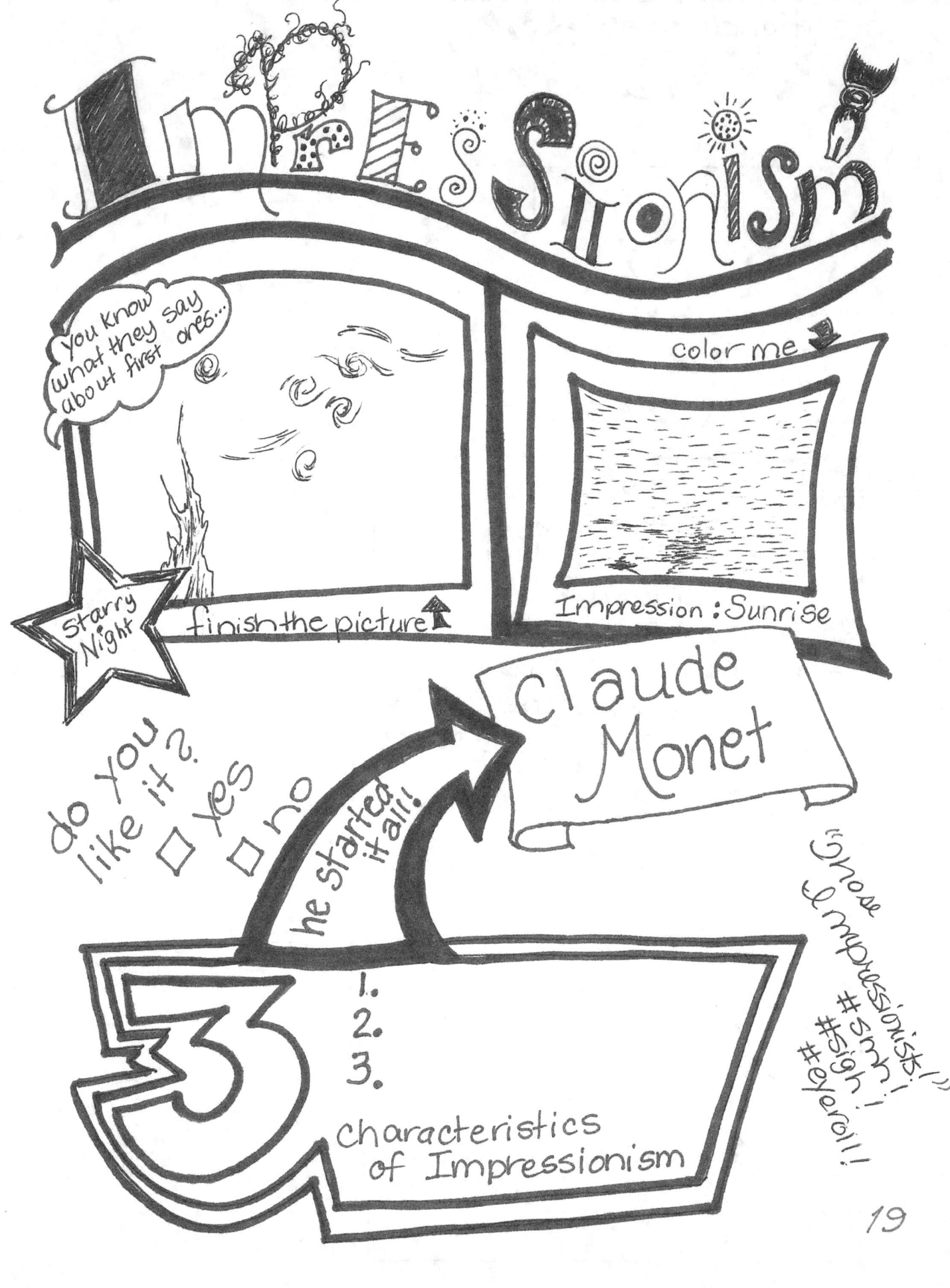

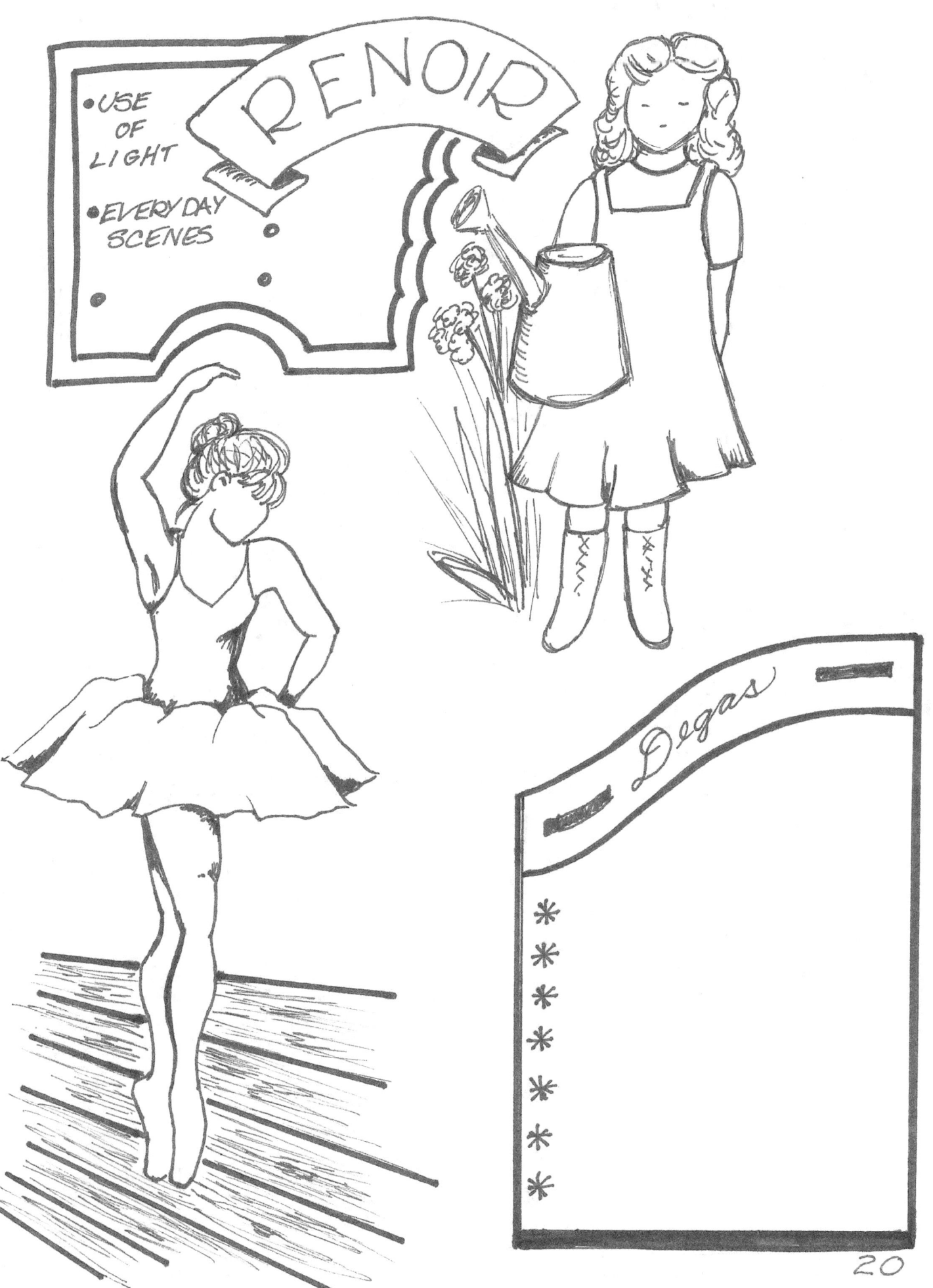

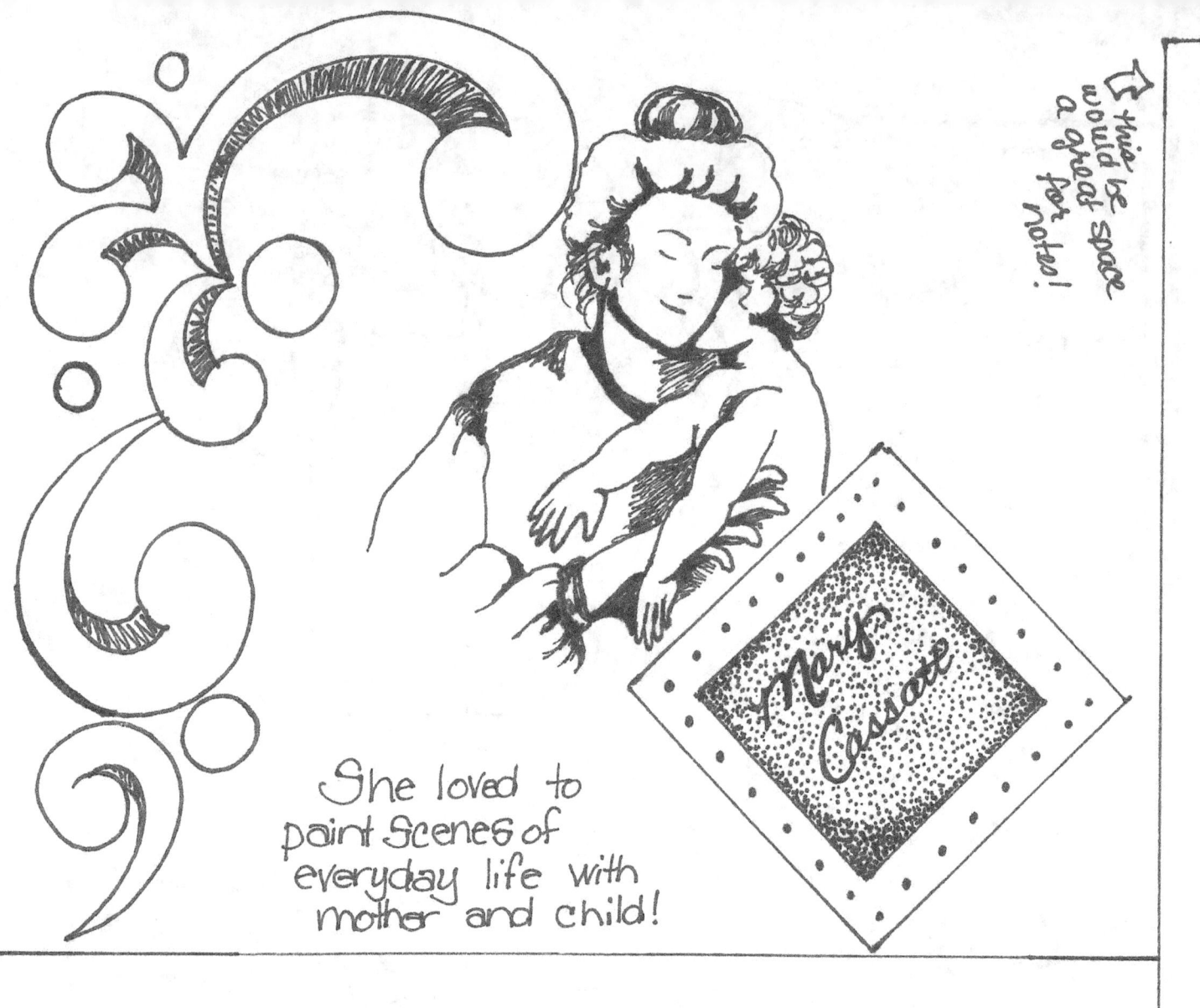

She loved to paint scenes of everyday life with mother and child!

Mary Cassatt

⇧ This would be a great space for notes!

CREATE A PICTURE OF YOUR CLASSROOM IN THE IMPRESSIONIST STYLE!

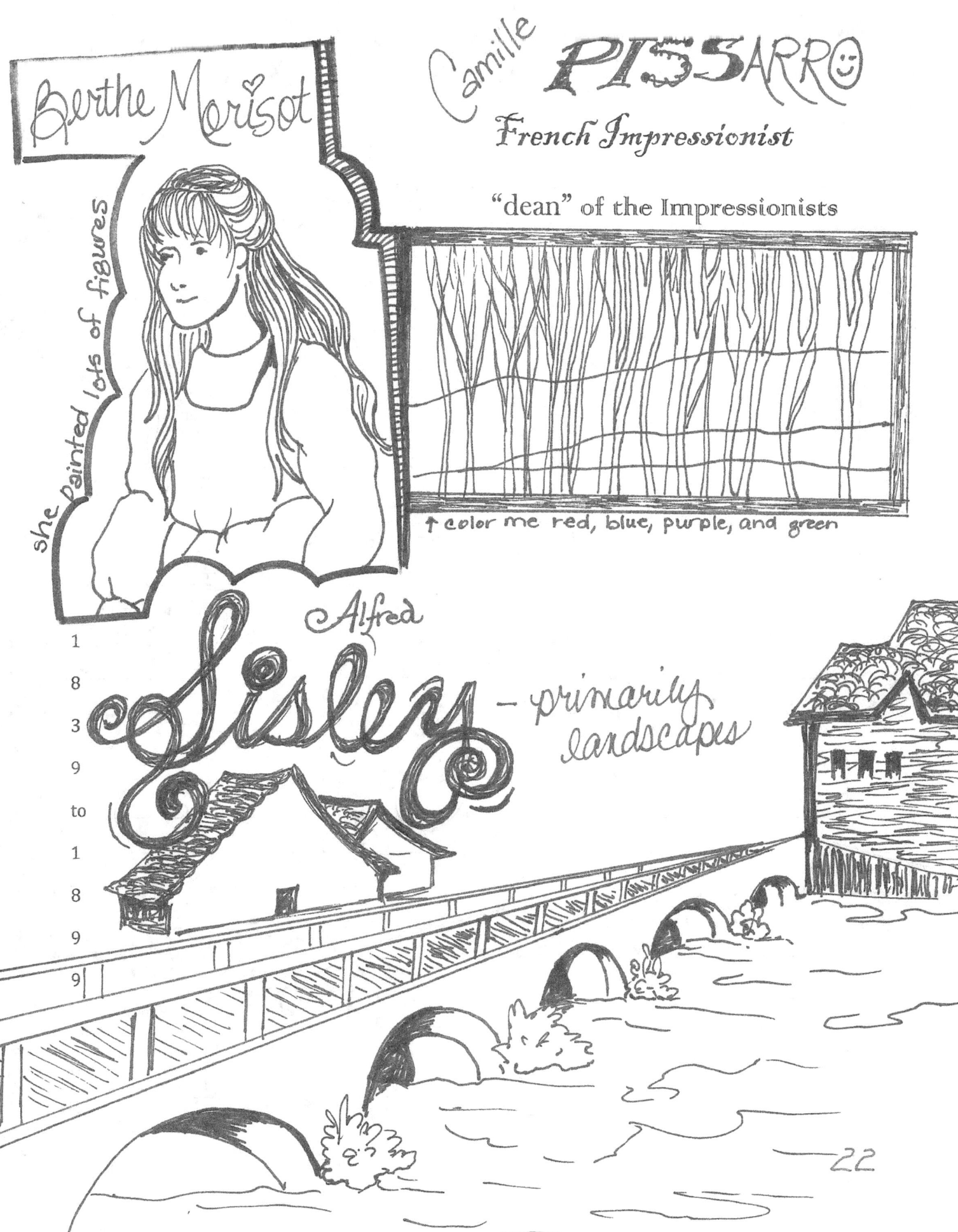

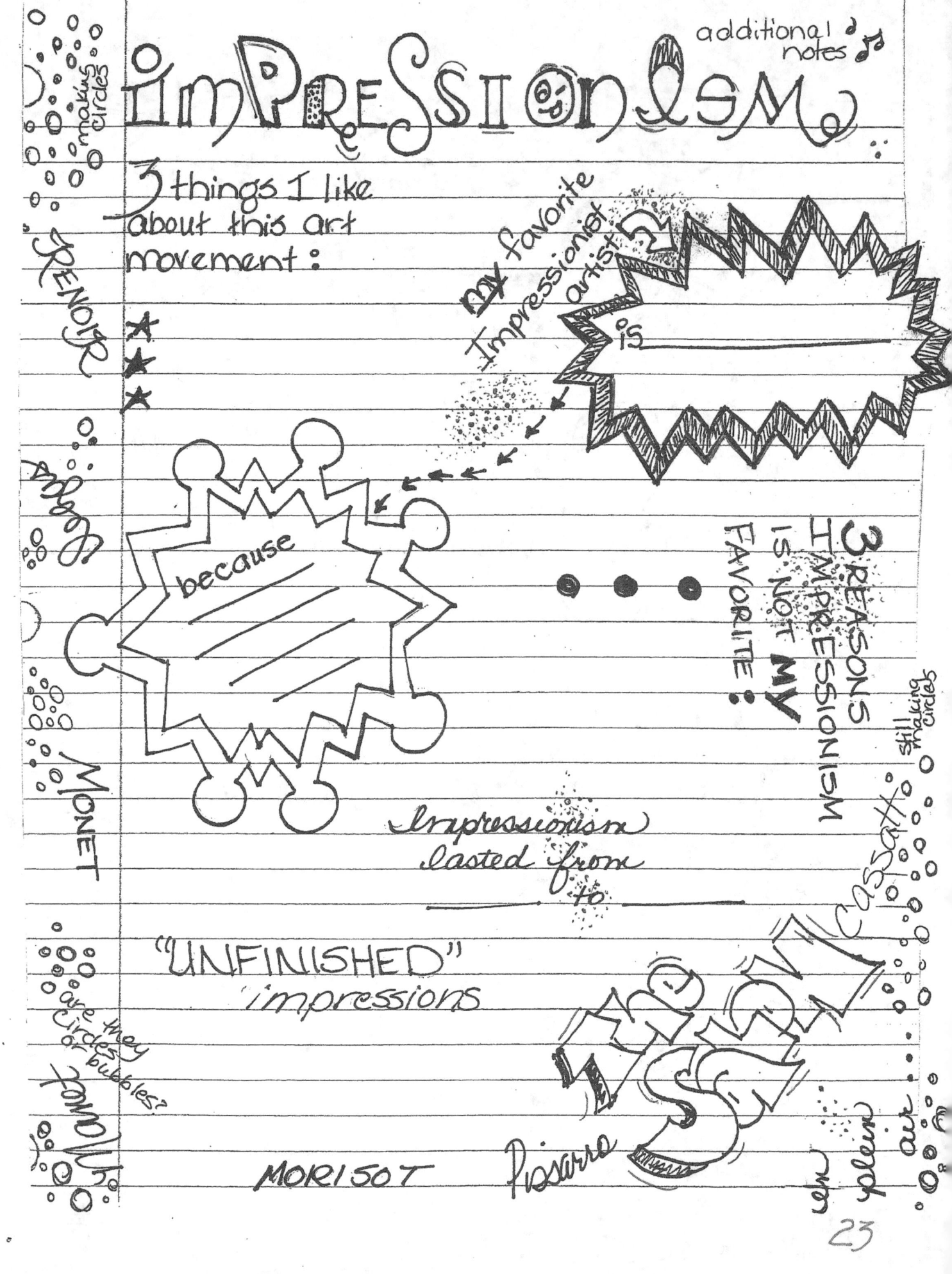

Rubric Score: _____/20_____

Lesson: _____ Name: _____

	0	1	2	3	4
Materials Use	Inappropriate use of materials	Incorrect use of materials for majority of work	Minimal correct use of materials	Mostly correct use of materials	Correct use of materials
Concept Comprehension	No work done	Minimal work done and the majority of concepts are applied incorrectly	Some work complete. Most concepts are incorrectly attempted	Majority of work displays evidence of comprehension with minimal elements missing	Work displays evidence of complete comprehension of concepts
Technique	No work done	Minimal or incorrect use of techniques required for successful completion of the lesson	Sporadic or incorrect use of presented techniques and the elements therein	Majority of techniques and the elements therein are present throughout the work	Continuous correct execution of all elements
Tidiness	No work done	Majority of work is smudged, bent, torn, ripped, or unacceptable	Much of the work is messy and contains compound issues of disregard for work	Work is mostly tidy with only minimal flaws creating little distraction	Work is clean, smudge-free, creaseless, and displays product to best advantage
Creativity	No work done	Minimal attempts at original ideas	Very little effort goes beyond the given facilitator concepts	Original ideas are being incorporated in concepts and techniques	Original ideas of good quality lend to overall viewer interest

Teacher comments:					

Student Comments:

Lesson Plans

samples attached

Teacher: _____

Subject: _____ Pd. _____

Unit: _____

Lesson: _____

Activity: _____

Date: _____

Description:

Frameworks:

SLEs:

CCSS:

Reflections:

Teacher: _____ Lesson: _____ Pd: _____

Subject: _____

Do you think the overall lesson/activity was successful? Y___ N___

Explain your answer

Pros: _____
Cons: _____
Things to tweak before I do this one again:

Reflections:

Teacher: _____ Lesson: _____ Pd: _____

Subject: _____

Do you think the overall lesson/activity was successful? Y___ N___

Explain your answer

Pros: _____
Cons: _____
Things to tweak before I do this one again:

Char Green is an Arkansas native. She is married to Tom Green and they have four grown children: Alex (Haley-daughter in love), Jake, Katie, and Meredythe. She has been an educator for 20 years and is currently a Gifted and Talented Coordinator and an Art teacher. Char is also an avid artist and a novice gardener. She spends her spare time painting, drawing, and attempting to grow things.

Please keep an eye out for "Doodle Your Way Thru...Art History, Vol. 2"

Coming Soon!

www.ingramcontent.com/pod-product-compliance
Lightning Source LLC
Chambersburg PA
CBHW081134180526
45170CB00008B/3106